Elad Lassry

White Cube

Picture Choreography

On 12 June I attended the final two performances of New York City Ballet's 2011 Spring season. The matinee was an all-Balanchine, all-Stravinsky programme of *Apollo, Monumentum oro Gesualdo, Movements for Piano and Orchestra, Agon* and *Symphony in Three Movements*. The evening performance was something different, a special event called Dancers' Choice in which dancers themselves choose the ballets and who dances them; many roles are taken by younger members of the company who are dancing in front of a public for the first time. *Apollo* and the pas de deux from *Agon* were repeated from the afternoon programme for Dancers' Choice, with debuts in all six roles. Although still a member of the corps de ballet, Megan LeCrone danced the principal ballerina part in the Agon pas de deux, one of the most coveted roles in the repertory. It wasn't the first time I had seen her dance it, at least the final minute of it. In January 2009, just as I was about to begin teaching a class on dance film at New York University, I wandered by chance into the Whitney Museum's exhibition of three of Elad Lassry's films. There, to my surprise and delight, I saw projected a film loop of LeCrone and City Ballet soloist Ask la Cour, framed from various angles so tightly as to radically fragment their bodies, repeatedly performing something entirely familiar. Although there was no music to confirm it, I recognised immediately that I was seeing the final moments of the pas de deux from George Balanchine's *Agon*, perhaps the greatest ballet pas de deux of the 20th century. What I learned by reading the exhibition handout was that the camera's viewpoint for each shot was plotted according to modern dance choreographer Doris Humphrey's famous diagram of the strong and weak points on a stage; this was included in her book *The Art of Making Dances*, published in 1959, the year after her death and two years after *Agon*'s premiere.

Familiarity and information notwithstanding, Lassry's *Untitled* (2007) is an enigmatic work. Balanchine's ballet masterpiece and Humphrey's choreographic manual constitute a pretext, a score or scenario of sorts, not the subject of the work. Neither is fully present in what we see. Yes, I can recognise a portion of the Agon pas de deux, but it doesn't explain much. It's of little more consequence than the familiarity to me, from other films, of the barres of the New York City Ballet studio (indeed, those distinctive ballet barres, made of blond wood and positioned on black supports at three heights about ten inches apart, were visible in a brief rehearsal film shown at Dancers' Choice). But still, dance seems hardly to be extraneous to Lassry's film, determined as it is by two signal dance works of the mid-20th century, and, moreover, Lassry has subsequently made three more 'dance films'. Lassry has used the word 'ghost' for this background information, suggesting that it is an absent presence, something that haunts what we see.

Let's look more carefully at what we do see. The film begins with a headshot of LeCrone, her head slightly cocked, looking pensive. She doesn't hold completely still, but rather adjusts her glance, shifts her weight, moves her hands as if to music that only she hears. Sometimes her

attention seems drawn to someone directly in front of her, where the camera is positioned, but apart from that her concentration appears to be inward. After just over two minutes there is a cut to an abstract composition formed by the ballet barres I mentioned above. Briefly we glimpse a hand on the right edge of the frame, and then La Cour's arm extends into the frame from the left. He continues to move into the frame until we see his face in profile and his white practice shirt-clad torso. LeCrone enters the frame from the right, grasps his left shoulder and right upper arm and leans into an arabesque. She rises back up, shifts her position so as to face the camera, and, supported by holding La Cour's arms at the elbow, tilts forward as he lowers his head to accommodate her movement. The motion continues as she rises back up and back down again, further this time, so that he has to bend his head sideways to accommodate her full extension. She returns to standing with her left leg still outstretched. Now she swings her leg all the way around from back to front; he takes hold of her thigh and they bend their upper bodies backwards, away from each other. As she returns to upright, he pushes her left leg in the opposite direction. As she extends it into arabesque again, he falls below the frame, evidently supporting her while lying down. After holding the hyper-extended arabesque penchée for several seconds, she returns to standing and he to kneeling in front of her. He reaches up and she simultaneously collapses forward into the tight embrace with which the pas de deux comes to its conclusion.

It is a pas de deux that I've seen scores of times since I first began attending New York City Ballet performances in the 1970s. Danced by great dancers like Suzanne Farrell and Peter Martins or Wendy Whelan and Albert Evans, it is one of the most sublime expressions of ballet modernism.[1] That sublimity is, as Lassry might say, only a ghost here. Deprived of Stravinsky's music, of the context of the full ballet, even of the full pas de deux, we see *Agon* here only as one element among others that make *Untitled* (2007) the curious work it is. *Agon*'s lack of transcendent beauty in this case might be symbolised by such a surely unintentional detail as the fact that when La Cour raises his arms in the pas de deux's denouement, we can't help but notice that there is a small rip in the right underarm of his stark white shirt (the ballet is performed, as is the case for many of Balanchine's modernist works, in black and white practice clothes).

The second of the seven repetitions of the single minute from *Agon* is shot not only from a different angle but also from a different distance and at a different height, so that this time we see the dancers' legs rather than their torsos. With their upper bodies and heads mostly cut off, what we're looking at would hardly be comprehensible had we not just seen the previous straight-on shot. We do see clearly this time La Cour's lying-down position from which he supports LeCrone's final arabesque before the pas de deux's closing collapse/embrace. The third take is framed much like the first. It begins with a very brief moment of the dancers marking the opening moments, after which they disappear beyond the frame before starting the pas de deux in earnest. In her

final extension, supported from La Cour's lying-down position, LeCrone slightly loses her balance, and a flicker of laughter appears on her face as she recovers. The fourth shot, from an angle opposite that of the second – stage left this time ('stage left' if we take the studio as a stage and the wall of the studio as up stage) – fragments the two dancers less than the previous shots did. Shot five shows the dancers from behind. We would never see them this way in a staged performance; and indeed it results in a full-on crotch shot of LeCrone, which Balanchine is unlikely to have sanctioned. On the other hand, we are privy to wonderful details of the pas de deux we would never otherwise see, such as both dancers' hands clasped behind LeCrone's buttocks in the final embrace. The sixth shot is a tight close-up again and begins with La Cour's black tights-clad thighs framed against the ballet barres, like a Brancusi against a Mondrian. Indeed, this section of the film so fully abstracts the dancers that we would have very little idea what was going on without the preceding takes. But there are terrific compositions, especially one in which LeCrone's toe shoe is tucked under La Cour's bicep and his other arm perfectly parallels her outstretched leg as they lean away from each other; and another in which her head, arm and torso occupy the entire frame in her final arabesque while he lies down completely out of the frame. The seventh shot of *Agon* is again from behind, but this time from the left of the dancers. Finally, there is a two-minute headshot of La Cour. He seems altogether less inward than LeCrone did in her opening portrait shot as he moves his head back and forth, apparently running through in his head the choreography he's just danced.

I come back to La Cour's torn T-shirt, which I noticed again in two other takes. There are other distracting details: La Cour's dirty ballet slippers, the seam of LeCrone's tights when seen from behind, the wobbly final embrace that should be held absolutely still. But more than this I am constantly aware of the film's structure, composed as it is of nine long takes, all of them from a fixed camera position: the opening and closing portraits of the two dancers lasting just over two minutes each, and the seven one-minute takes of the pas de deux. I am conscious of the change in angle from which the pas de deux is shot. I am struck by how fully the camera flattens the dancers' limbs and torsos into patterns. As a lover of Balanchine's high modernist choreography, which attunes the spectator to movement patterns devoid of narrative meaning, I can't help but read Lassry's film as extending Balanchine's own abstraction of the ballet body. The film's silence (a silence in the viewer's space that is nevertheless filled with the sound of the film looper) is also conspicuous since the dance movement so urgently misses its accompanying music. You can't even 'hear' the absent Stravinsky music in your mind, since neither the music nor the dancing has an obvious rhythm (the pas de deux was once described as 'one long, long breath'). These structural elements – fixed camera positions, framing that calls attention to itself, predictable shot durations, repetition and variation, palpable silence but for the sound of the apparatus – recall the structural cinema of the 1960s and '70s. Even more, the arbitrary determining system that scores the film –

the final minute of the *Agon* pas de deux shot according to Humphrey's dance diagram – recalls that moment when structural film, conceptual art and post-Judson dance shared systemic compositional methods. Think, for example, of Hollis Frampton's *Zorns Lemma* (1970); Sol LeWitt's *Incomplete Open Cubes* (1974); and Trisha Brown's *Locus* (1975). Because Lassry's *Untitled* (2007), shown as a continuous loop, is a gallery work, it also recalls the work of Paul Sharits, the structural filmmaker who exhibited his work in a similar manner (I think especially of Sharits's *Shutter Interface* (1975), recently restored and shown at the Greene Naftali Gallery in New York). But in spite of his use of predetermined structuring systems and procedures that draw attention to the purely cinematic, Lassry is no structural filmmaker.

Lassry is a picture-maker. And I use the word *picture* advisedly. There is of course another artist Lassry's work recalls, who also made films for the art gallery context, and that is Jack Goldstein. Lassry's looped projections, the relatively small size of the projected image, the saturated colour, and even some of the motifs – animals, pointe shoes, paintings – make clear reference to Goldstein's films of the mid-1970s. But whereas Goldstein's films are highly condensed events often taking only a few minutes or less – a dog barking in *Shane*, the MGM lion roaring in *Metro-Goldwyn-Mayer*, the descent from *en pointe* in *A Ballet Shoe* (all from 1975) – Lassry's films are drawn out, measuredly repetitive, all but drained of the energy inherent in their dance subjects.

Let's look at another example. In *Untitled (Passacaglia)* (2010) Lassry returns to Doris Humphrey and, more tangentially, Balanchine – Humphrey for her 1938 dance choreographed to Bach's *Passacaglia and Fugue in C Minor*; Balanchine for the New York City Ballet dancers trained in his technique at the School of American Ballet. *Untitled (Passacaglia)* begins not with a portrait of a dancer but a detail of a painting over which the camera begins a series of slow pans – to the right, up and then back down, right, up then down, right, up then down, right for a final time, and then down. This takes five minutes, 45 seconds. The painting is Robert Delaunay's *La grande portugaise* (1916), or rather it is a stage prop version of it; it plays no other role in the film except as the background for a sustained bust-length portrait of three dancers that forms the conclusion. The second shot is also a pan, this one to the right, then up, showing a close-up configuration of dancers wearing beige unitards. The first one we see is a kneeling man, his hands clasped behind his neck such that his elbows project in front of his backward-tilted head. The pan continues past him to reveal, in a characteristically awkward moment of framing, a woman's legs from just below the waist to just below the knees. The upward pan shows this to be Megan LeCrone – whom we recognise from *Untitled* (2007) – her arms interlinked with those of another dancer. When the camera pans right we see that there are four women with their arms configured into a chain. They move the configuration back and forth in rhythmic jerks, although, again characteristically, the framing cuts off their arms below the shoulders. When the camera tilt-pans downward, we see more of

what had been very slightly visible behind LeCrone's legs: a stepped platform on which the dancers are arranged, painted white and covered with drips of primary colour. A cut shows three women dancers standing in front of the platform who begin dancing a phrase that repeats and reverses. As they continue dancing they eventually ascend the platform, and as the ascent continues, nine dancers moving in unison come into the frame. They assume a series of hieratic poses, and a male dancer in the centre performs an arabesque. He is four steps down from the top of the platform, and a few moments later, having resumed his kneeling position, he grins, as if he finds the exercise faintly ridiculous and cannot keep a straight face.

The stepped platform is telling. I haven't seen Humphrey's *Passacaglia* either staged or on film, but photographs of Humphrey's works from the 1930s often show similarly constructed modular stage props that look like a cross between bleachers and minimal sculptures. They very clearly function integrally to the starkly formal composition of the dance. But for Lassry they are something more. Like the graphic geometry of the ballet barres in *Untitled* (2007), or the brightly coloured plinths in another of his 'dance films', *Untitled* (2009), which stages the moment of Jerome Robbins coaching Mary Martin how to 'fly' in the Broadway production of *Peter Pan*, the elaborate stage prop in *Untitled (Passacaglia)* is yet another 'ghost', obliquely referring to minimalism through its form, to Pollock through its drips, to period décor through its pale colour scheme. I suspect it is also a reference to the notion of a staged picture, which, quite apart from the operations of appropriation, is so essential to the work of the Pictures artists of the 1970s and '80s, to whose work Lassry is clearly indebted. Minimalist plinths often appear in Lassry's photographs as well as his films, usually as the base or stand on which objects such as figurines, vegetables or photographs within the photograph are displayed. But these plinths are only one of many staging strategies in the photographs, whose function is the structural equivalent in the still pictures to framing in the films. Unlike the filmed dance subjects – *Agon*, *Passacaglia*, *Peter Pan* – the photographic subjects are often perfectly centred and call little or no attention to what is outside the frame. The staging devices are many: besides the plinths there are reflective surfaces, patterned backgrounds, shadows that suggest dimension, colour contrasts, collaged elements. But none is more insistent than the literal frame, which picks up the most vivid colour of what is pictured and makes it cloying. 'This is an object', it seems to insist, 'for presentation and display' – I borrow the title of Louise Lawler and Allan McCollum's *Ideal Settings: For Presentation and Display*, a work of 1983–84 that consists of dramatically lit display stands arrayed on a series of stepped pedestals that look like nothing so much as a prop for a Doris Humphrey dance. Nor are the photographic subjects as recherché as *Agon* and *Passacaglia*. They are portraits of people and animals, and still-lifes of fruits and vegetables and commercial products of various kinds. Some photographs are appropriated, such as movie-star portraits of Anthony Perkins and advertising pictures from old magazines.

Various techniques are used to increase artifice: double exposures, blurs, colour bars blocking out parts of the image, seamless backgrounds, florid or geometric backgrounds, colour coordination. The objects are often bizarre: silver vases in the shape of faces, a quilted-satin abstract relief. The people often look unreal or even slightly creepy: too pretty, they're less glamorous than decorative. The art references sometimes seem tongue in cheek: Hans Arp, Jeff Koons, Haim Steinbach. But nothing affects our sense of these pictures – of what's distinctive about them, what's wrong with them, or, as one critic wrote, what's *irritating* about them[2] – more than their framing. By framing I mean not only the actual picture frames and the matching of the colour of the frame with that of the photograph but also the framing of the objects *within* the pictures, the space or lack of space those objects occupy, the mise en scène of their presentation, the complex choreography of the picture.

It is remarkable how that framing can be at once formally arresting and utterly absurd. Many of the shots of Lassry's film *Untitled* (2009) (the Peter Pan rehearsal) show the performer's legs in red tights dangling into the picture from above. In their gently curving shape and mobility, they contrast with the geometric vertical stripes formed by the columnar structures of the set. As the dancer's legs move into flying position, it's hard not to laugh. But then the film cuts to the Jerome Robbins figure played by Eric Stoltz, who looks anything but amused (Robbins was a notoriously difficult task master). Again the legs fly back and forth in front of the bright colours of the columns – grey, yellow, grey, black, grey, green, grey (grey is presumably the background colour, but all you see are vertical colour bars). A cut to the dancer's face listening attentively, responding cheerfully. Whom does she listen to? Stoltz? Lassry? Robbins' ghost? Mary Martin's? J.M. Barrie's? Maybe it's our questions she listens to – about this puzzling picture whose choreography she enacts.

Douglas Crimp

1. Whelan is white and Evans is black. This inter-racial coupling was also the case of the two principals for whom Balanchine made *Agon*, Diana Adams and Arthur Mitchell. Also, as dance critic Edwin Denby wrote at the time, 'The fact that Miss Adams is white and Mr. Mitchell Negro is neither stressed nor hidden; it adds to the interest.' See 'Three Sides of Agon' in *Dance Writings* (Alfred A Knopf, New York 1986). In fact, such a highly charged pas de deux danced by a mixed race couple in 1957 was certainly daring.

2. See Beatrix Ruf, 'Introduction' in *Elad Lassry* (Kunsthalle Zürich, 2010), p.71.

Coyfish
2011
C-print, painted frame
Edition of 5
11 1/2 x 14 1/2 x 1 1/2 in. (29 x 36.5 x 4 cm)

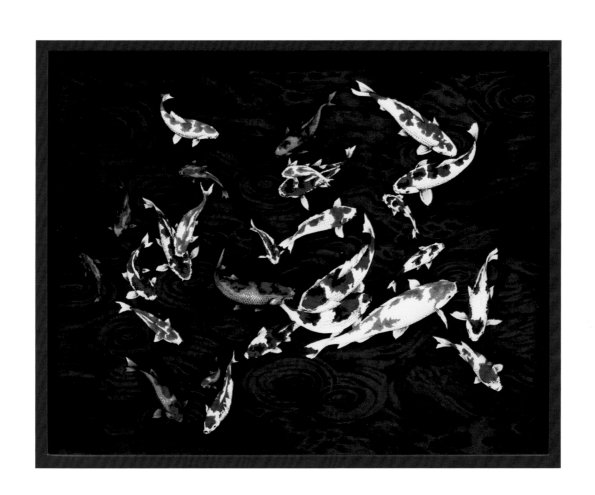

Gourds B
2011
C-print, painted frame
Edition of 5
14 1/2 x 11 1/2 x 1 1/2 in. (36.5 x 29 x 4 cm)

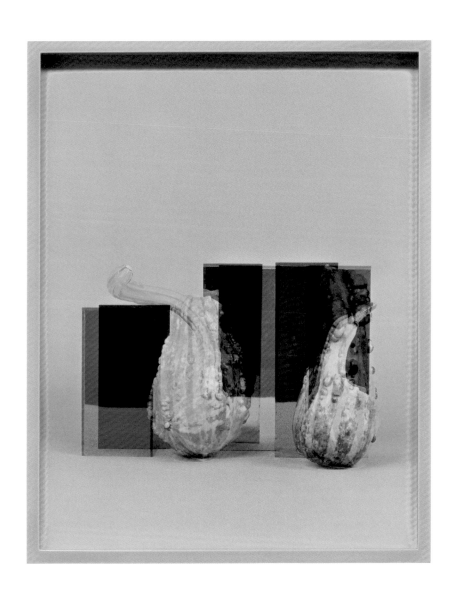

Untitled (Silver Bar, Dance)
2011
Foil on silver gelatin print, aluminium frame
Unique
9 3/4 x 7 1/2 x 1 1/2 in. (24.8 x 19.1 x 3.8 cm)

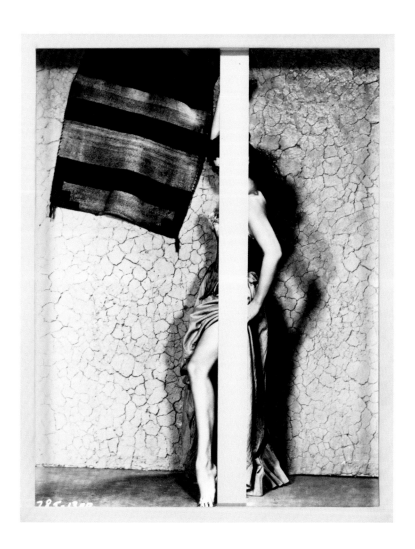

Herend (Three Pigs)
2011
C-print, painted frame
Edition of 5
11 1/2 x 14 1/2 x 1 1/2 in. (29 x 36.5 x 4 cm)

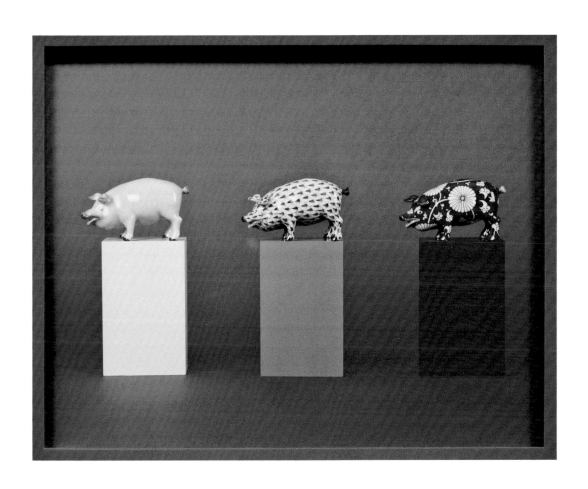

Landscape 91608
2011
C-print, walnut frame
Edition of 5
11 1/2 x 14 1/2 x 1 1/2 in. (29 x 36.5 x 4 cm)

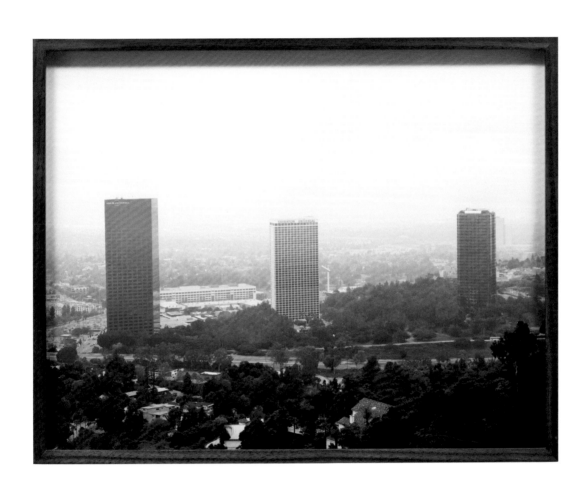

Collie, Poodle
2011
C-print, painted frame
Edition of 5
11 1/2 x 14 1/2 x 1 1/2 in. (29 x 36.5 x 4 cm)

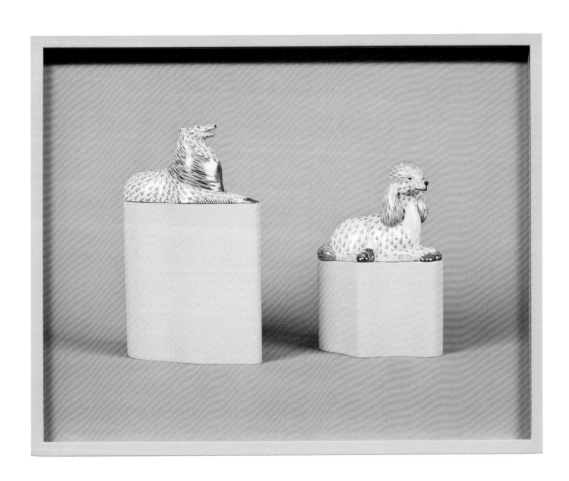

Cat and Duck (Red)
2011
C-print, painted frame
Edition of 5
14 1/2 x 11 1/2 x 1 1/2 in. (36.5 x 29 x 4 cm)

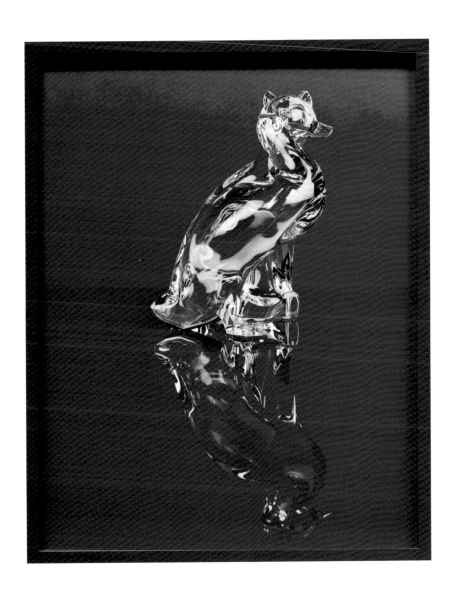

Laminated Structure (For Bath)
2011
C-print on c-print, painted frame
Unique
14 1/2 x 11 1/2 x 1 1/2 in. (36.5 x 29 x 4 cm)

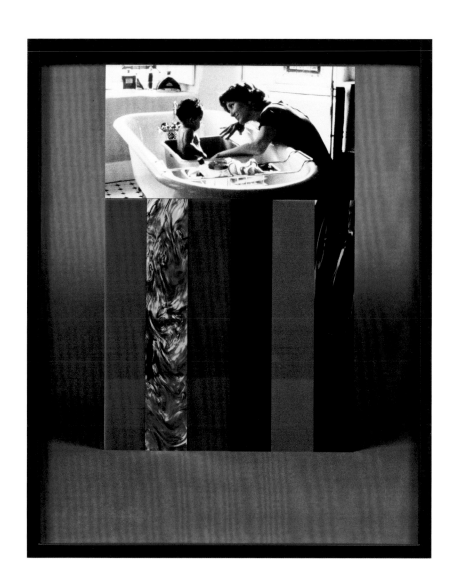

Man, Two Women (Puzzle)
2011
C-print, painted frame
Edition of 5
14 1/2 x 11 1/2 x 1 1/2 in. (36.5 x 29 x 4 cm)

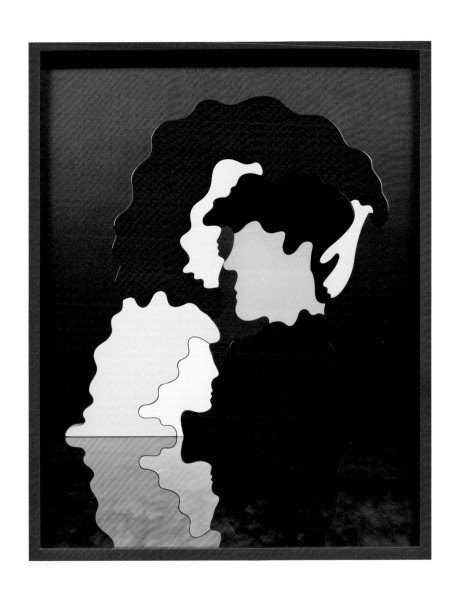

Pillow 2
2011
C-print, painted frame
Edition of 5
14 1/2 x 11 1/2 x 1 1/2 in. (36.5 x 29 x 4 cm)

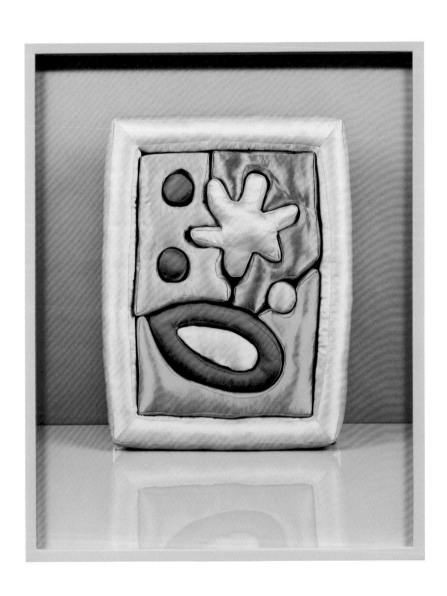

Woman (Beads)
2011
C-print, painted frame
Edition of 5
14 1/2 x 11 1/2 x 1 1/2 in. (36.5 x 29 x 4 cm)

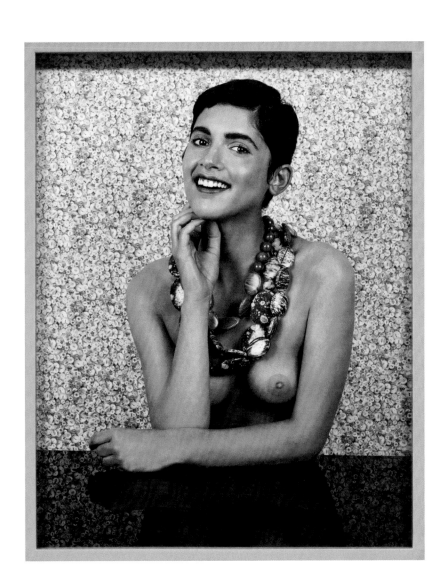

Cat and Duck
2011
Silver gelatin print, walnut frame
Edition of 5
14 1/2 x 11 1/2 x 1 1/2 in. (36.5 x 29 x 4 cm)

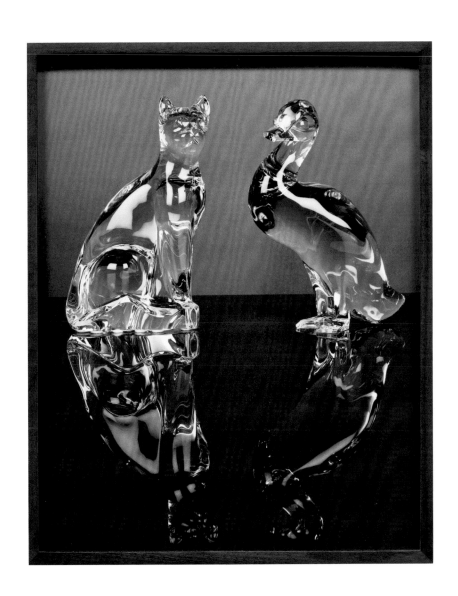

Devon Rex
2011
C-print, painted frame
Edition of 5
14 1/2 x 11 1/2 x 1 1/2 in. (36.5 x 29 x 4 cm)

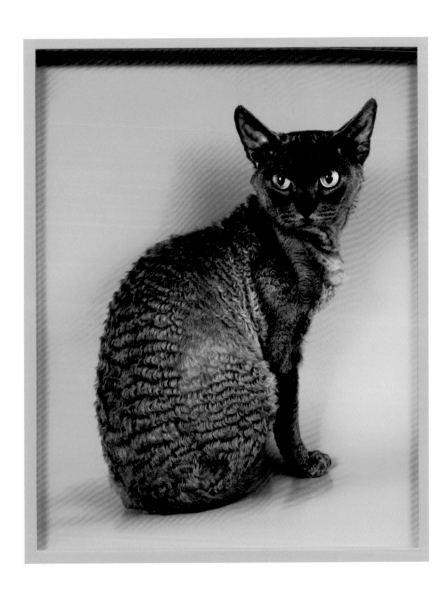

Plinth (Orange Liquid)
2011
Silver gelatin print on c-print, painted frame
Unique
14 1/2 x 11 1/2 x 1 1/2 in. (36.5 x 29 x 4 cm)

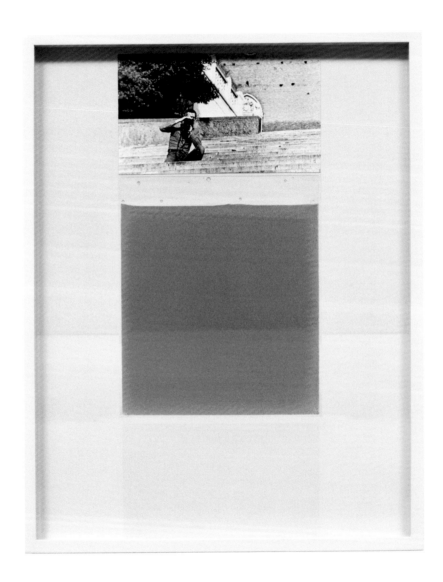

Fringe
2011
C-print, painted frame
Edition of 5
14 1/2 x 11 1/2 x 1 1/2 in. (36.5 x 29 x 4 cm)

Cub, Raccoon
2011
C-print, brass frame
Edition of 5
14 1/2 x 11 1/2 x 1 1/2 in. (36.5 x 29 x 4 cm)

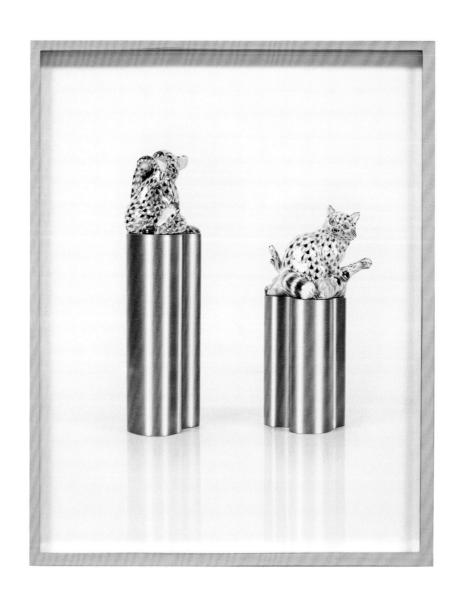

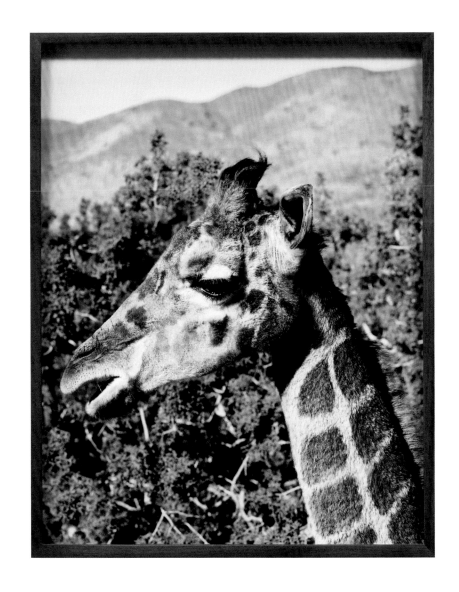

Giraffe, 93040
2011
Silver gelatin print, walnut frame
Edition of 5
Diptych. Each: 14 1/2 x 11 1/2 x 1 1/2 in. (36.5 x 29 x 4 cm)

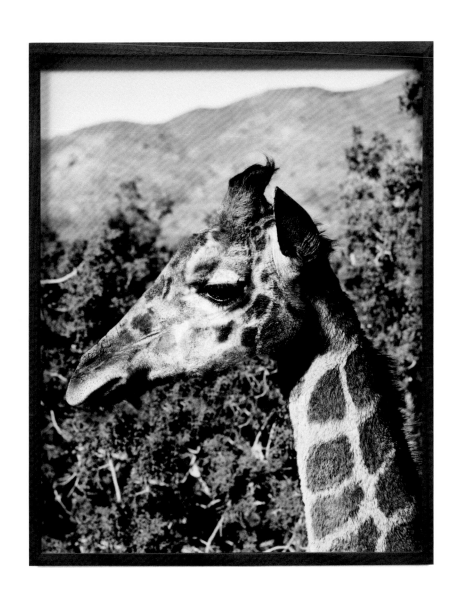

Compacts
2011
C-print, painted frame
Edition of 5
14 1/2 x 11 1/2 x 1 1/2 in. (36.5 x 29 x 4 cm)

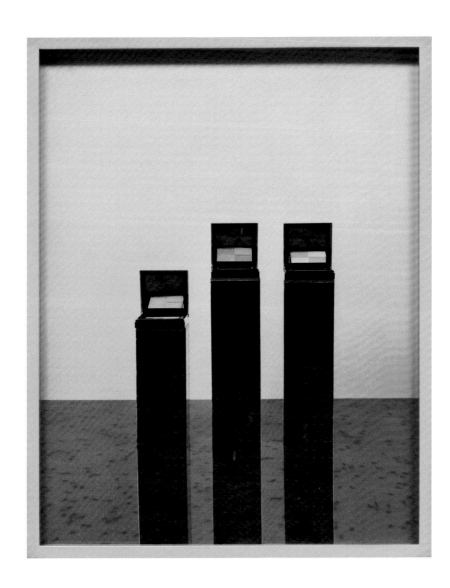

Net
2011
C-print, painted frame
Edition of 5
11 1/2 x 14 1/2 x 1 1/2 in. (29 x 36.5 x 4 cm)

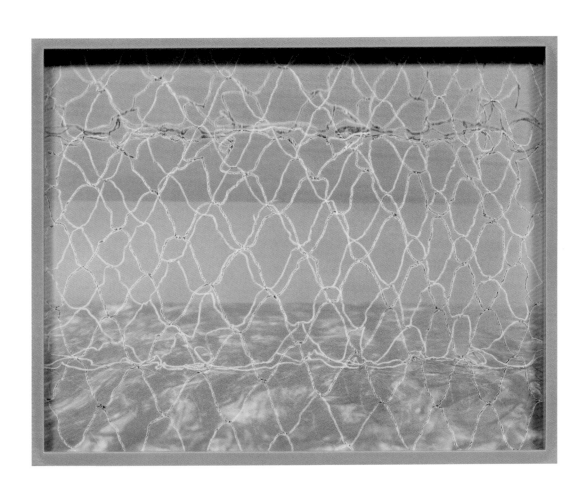

Portrait 2 (Baby Blue)
2011
C-print, painted frame
Unique
10 1/2 x 8 1/2 x 1 1/2 in. (26.7 x 21.6 x 4 cm)

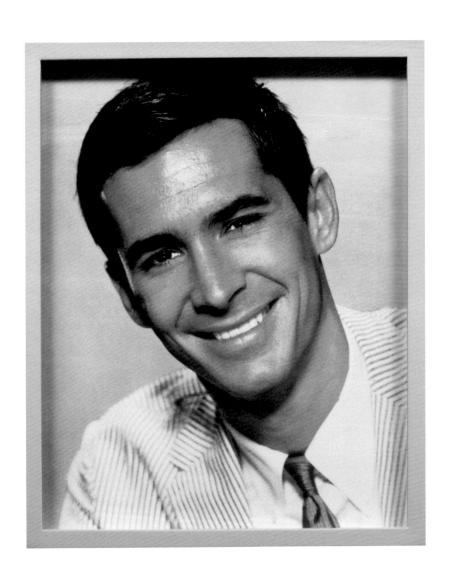

Walnut (Purple)
2011
C-print, painted frame
Edition of 5
14 1/2 x 11 1/2 x 1 1/2 in. (36.5 x 29 x 4 cm)

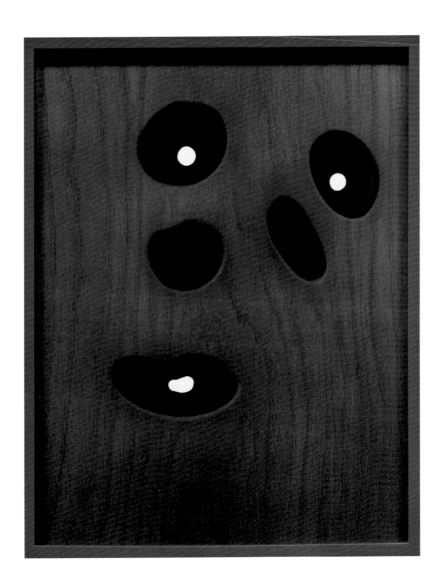

Sterling Silver Vases
2011
C-print, painted frame
Edition of 5
11 1/2 x 14 1/2 x 1 1/2 in. (29 x 36.5 x 4 cm)

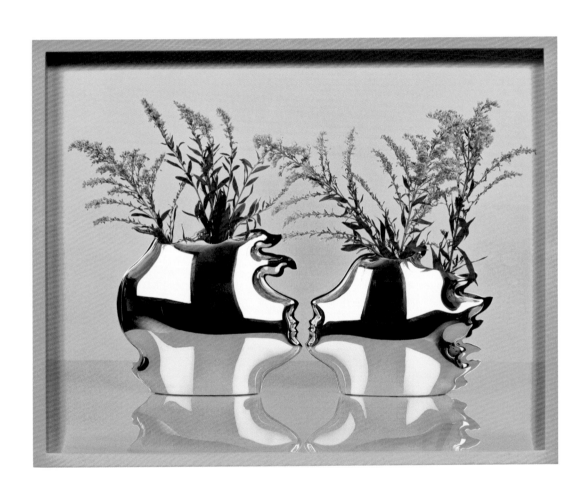

Sterling Silver Vase
2011
C-print, aluminium frame
Edition of 5
14 1/2 x 11 1/2 x 1 1/2 in. (36.5 x 29 x 4 cm)

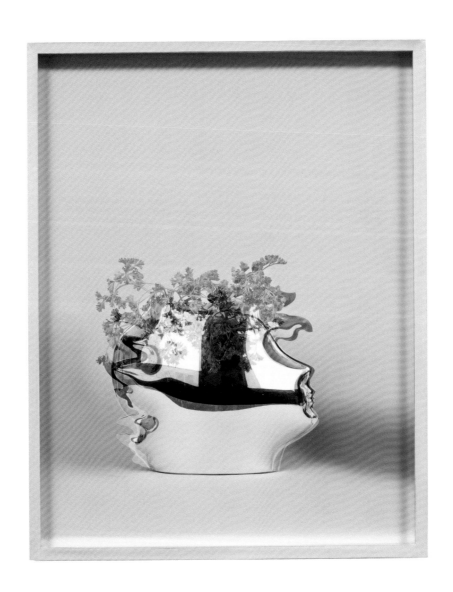

Untitled (Blue Bar, Mural)
2011
Foil on c-print, painted frame
Unique
10 1/8 x 7 1/2 x 1 1/2 in. (25.7 x 19.1 x 3.8 cm)

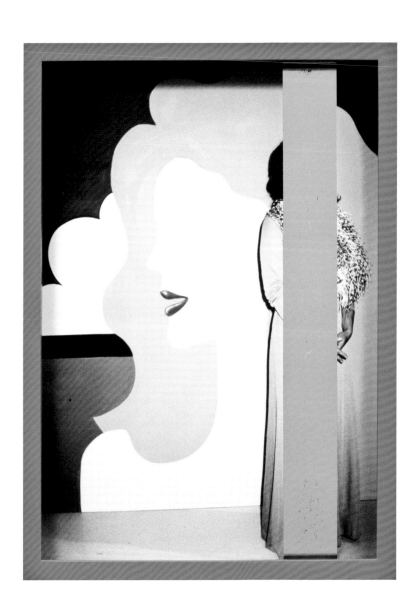

Three Men
2011
C-print, painted frame
Edition of 5
11 1/2 x 14 1/2 x 1 1/2 in. (29 x 36.5 x 4 cm)

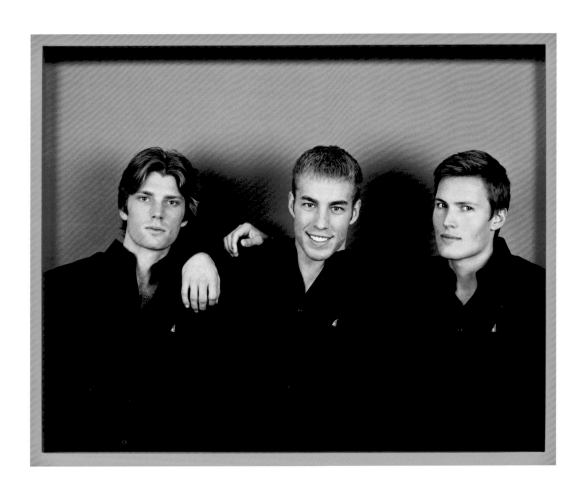

Eggs (Three)
2011
C-print, painted frame
Edition of 5
11 1/2 x 14 1/2 x 1 1/2 in. (29 x 36.5 x 4 cm)

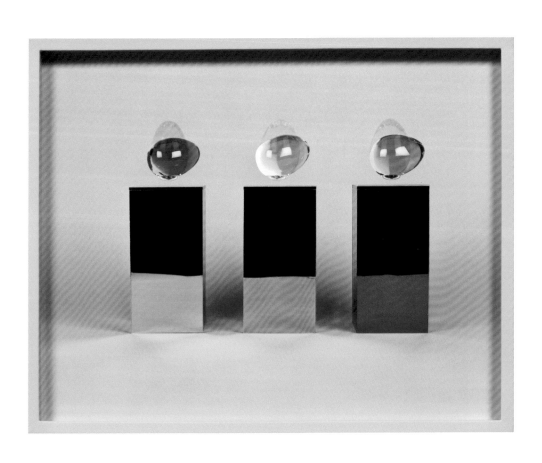

Gourds A
2011
C-print, painted frame
Edition of 5
14 1/2 x 11 1/2 x 1 1/2 in. (36.5 x 29 x 4 cm)

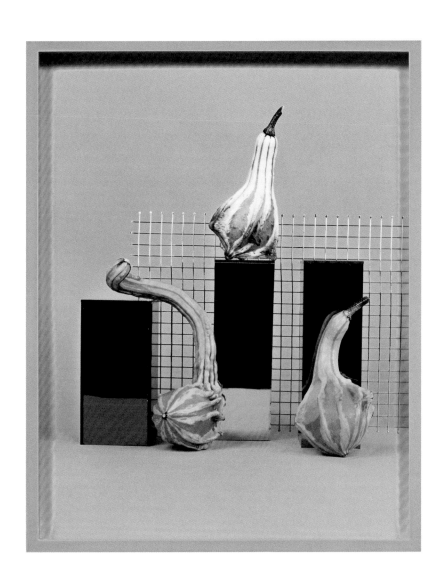

Pink Forks
2011
C-print, painted frame
Edition of 5
14 1/2 x 11 1/2 x 1 1/2 in. (36.5 x 29 x 4 cm)

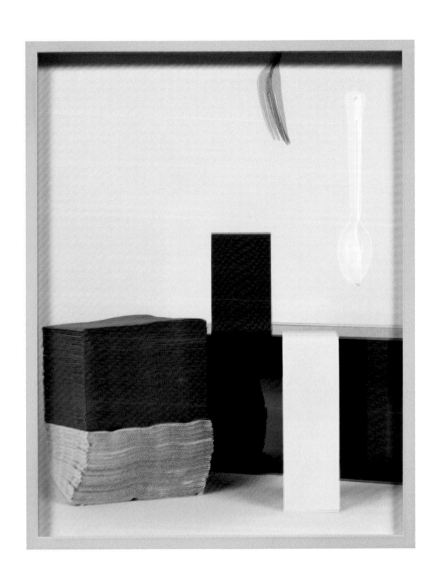

Girl (Set)
2011
Silver gelatin print, walnut frame
Edition of 5
14 1/2 x 11 1/2 x 1 1/2 in. (36.5 x 29 x 4 cm)

Elad Lassry

Lives and works in Los Angeles
2007 MFA, University of Southern California, Los Angeles
2003 BFA, California Institute of the Arts, Valencia, California
1977 Born in Tel-Aviv, Israel

Solo Exhibitions

2011 'Elad Lassry', Galerie Francesca Pia, Zurich

2010 'Elad Lassry', Luhring Augustine, New York
 'Elad Lassry: Sum of Limited Views', Contemporary Art Museum St. Louis, Missouri
 'Elad Lassry', Massimo De Carlo, Milan
 'Elad Lassry', Kunsthalle Zurich

2009 'Elad Lassry', David Kordansky Gallery, Los Angeles
 'Elad Lassry: Three Films', Whitney Museum of American Art, New York

2008 'Elad Lassry', Art Institute of Chicago
 'Elad Lassry: Tunnel Room', John Connelly Presents, New York
 'The Artist Moving Image Exhibition: Elad Lassry/Daria Martin', The Fashion Museum,
 Bath Film Festival, UK

2007 'Elad Lassry: She Takes These Pictures of His Wife Silhouetted on a Hillside',
 Cherry and Martin, Los Angeles
 'Elad Lassry: Driving up the Canyon She Saw a Dog', University of Southern
 California, Los Angeles

2003 'Elad Lassry: New Photos', 18th Street Arts Complex, Santa Monica, California

Group Exhibitions

2011 'ILLUMInations', International Pavilion, 54th Venice Biennale
 'Everything You Can Imagine Is Real', Xavier Hufkens Gallery, Brussels
 'Untitled (Evidence)', The David Roberts Art Foundation, London
 'Deutsche Börse Photography Prize 2011', The Photographers' Gallery, London
 'The Anxiety of Photography', Aspen Art Museum, Colorado
 'Secret Societies', Schirn Kunsthalle, Frankfurt; CAPC de Bordeaux, France

2010 'Paying A Visit To Mary Part 2', Kunstverein, Amsterdam
 'BigMinis: Fetishes of Crisis', CAPC, Musée d'Art Contemporain de Bordeaux, France
 'Les Rencontres d'Arles 2010: Edition 41', Arles, France; Garage Center for
 Contemporary Culture, Moscow

'Triumphant Carrot: The Persistence of Still Life', Contemporary Art Gallery, Vancouver
'Photos and Phantasy: Selections from the Fredrik R. Weisman Foundation', Beverly Hills Municipal Gallery, California
'New Photography 2010', Museum of Modern Art, New York
'Permanent Mimesis: An Exhibition on Realism and Simulation', Galleria Civica d'Arte Moderna e Contemporanea, Turin, Italy
'At Home/Not At Home: Works from the Collection of Martin and Rebecca Eisenberg', Center for Curatorial Studies, Bard College, Annandale-on-Hudson, New York

2009 'Dance with Camera', Institute of Contemporary Art, Philadelphia; Contemporary Arts Museum, Houston; Scottsdale Museum of Contemporary Art, Arizona
'The Perpetual Dialogue', Andrea Rosen Gallery, New York
'Beg, Borrow and Steal', Rubell Family Collection, Miami
'John Armleder and Elad Lassry', Carlson, London
'Berlin – Los Angeles: A Tale of Two (Other) Cities', Galleria Massimo de Carlo, Milan
'The Reach of Realism', Museum of Contemporary Art, North Miami, Florida
'Pete and Repeat', Zabludowicz Collection, London
'Looking Back: The White Columns Annual', White Columns, New York
'Superficiality and Superexcrescence', Ben Maltz Gallery, Otis College of Art and Design, Los Angeles
'The Generational: Younger Than Jesus', New Museum of Contemporary Art, New York

2008 'Front Room', Contemporary Art Museum, St. Louis, Missouri
'Half-Life', Los Angeles Contemporary Exhibitions
'2008 California Biennial', Orange County Museum of Art, Newport Beach, California
'Photos and Phantasy', Carnegie Art Museum, Oxnard, California
'Past-Forward', Zabludowicz Collection, London
'You, Whose Beauty Was Famous in Rome', Mandarin Gallery, Los Angeles

2007 'I Am Eyebeam', Gallery 400, University of Illinois at Chicago

2006 'LA25', Skadden, Los Angeles

2005 'Defense: Body and Nobody in Self Protection', Sweeney Art Gallery, University of California, Riverside

2002 'You'll Be My Footage', Wedge Gallery, Los Angeles

Selected Bibliography

Monographs and General Publications

Curiger, Bice and Giovanni Carmine (eds.), *ILLUMInations: 54th International Art Exhibition La Biennale di Venezia* (Marsilio Editori, Venice 2011)
Thompson, Matthew, Anne Ellegood and Jenelle Porter, *The Anxiety of Photography* (Aspen Art Museum, Colorado 2011)
Braun, Stefanie (ed.), *Deutsche Börse Photography Prize 2011: Thomas Demand/Roe Ethridge/Jim Goldberg/Elad Lassry* (Photographers' Gallery, London 2011)
Time Again (Sculpture Center, New York 2011); texts by Richard Aldrich, Moyra Davey, Jacob King, William E. Jones, Isla Leaver-Yap, Fionn Meade and Steve Roden
Lee, Evan, Trevor Mahovsky and Jenifer Papararo, *Triumphant Carrot: The Persistence of Still Life* (Contemporary Art Gallery, Vancouver 2010)
Les Rencontres d'Arles 2010: Heavy Duty and Razor Sharp (Actes Sud, Arles 2010)
Higgs, Matthew, *At Home/Not At Home: Works from the Collection of Martin and Rebecca Eisenberg* (Center for Curatorial Studies, Bard College, New York 2010)
Rabbottini, Alessandro (ed.), *Permanent Mimisis: An Exhibition on Realism and Simulation* (Fondazione Torino Musei, Milan 2010)
Ruf, Beatrix (ed.), *Elad Lassry* (JRP Ringier, Zurich 2010)
Roselione-Valadez, Juan (ed.), *Beg, Borrow, and Steal* (Rubell Family Collection, Miami 2009)
Heideinreich, Stefan and Thomas Lawson, *Berlin – Los Angeles: A Tale of Two (Other) Cities* (Galleria Massimo De Carlo, Milan 2009)
Mara De Wachter and Elizabeth Neilson (eds.), *Pete and Repeat* (Zabludowicz Collection, London 2009)
Dorin, Lisa, *Film, Video, New Media at the Art Institute of Chicago* (Art Institute of Chicago and Yale University Press, New Haven 2009)
Bedford, Christopher, Kristina Newhouse and John Welchman, *Superficiality and Superexcrescence* (Ben Maltz Gallery, Otis College of Art and Design, Los Angeles 2009)
Hoptman, Laura, *Younger Than Jesus: The Generation Book* (New Museum of Contemporary Art, New York and Steidl, Göttingen 2009)
Solomon, Thomas, *Half-Life* (Los Angeles Contemporary Exhibitions, Los Angeles 2008)
Decter, Joshua, Lauri Firstenberg and Rene Peralta, *2008 California Biennial* (Orange County Museum of Art, Newport Beach, California 2008)
Honoré, Vincent (ed.), *Past-Forward* (Zabludowicz Collection, London 2008)

Selected Newspaper and Magazine Articles

Goldstein, Andrew M., 'Light Show: Searching for Substance in the Venice Biennale's 'ILLUMInations' Exhibition,' *artinfo.com*, 17 June 2011
'Venice: Elad Lassry at the Arsenale', *Contemporary Art Daily*, 8 June 2011
McLean-Ferris, Laura, '54th Venice Biennale: Tapping the light fantastic', *The Independent*, 7 June 2011
Sherwin, Skye, 'In Pictures | Venice Biennale Highlights', *AnOtherMag.com*, 6 June 2011

Luse, Mimi, 'Venice Biennale Dispatch, Part One: The Group Show & Ai Wei Wei', *BlackBookMag.com*, 2 June 2011
Verde, Simone, 'Venezia s'illumina d'arte', *EuropaQuotidiano.it*, 1 June 2011
'More Than Meets the Eye', *AspenDailyNews.com*, 27 May 2011
Guzman, Alissa, 'Points of Departure', *The Times Quotidian*, 18 May 2011
'Review @ Xavier Hufkens: Everything You Can Imagine Is Real', *Pulp Gazette*, May 2011
Matalon, Rebecca, 'Time Again', *Kaleidoscope*, No.11, Summer 2011, p.90
'Portfolio: Elad Lassry', *Monopol*, May 2011
Scoccimarro, Antonio, 'Diary: Untitled (Evidence), From Alternative Knowledge to Counter-Memories', *Mousse*, No.29, Summer 2011, p.242
Tavecchia, Elena, 'Time Again', *Mousse*, No.29, Summer 2011, p.160
'Double Vision', *The Jewish Chronicle*, 15 April 2011, p.24
Bradley, Laura, 'Who, What, Why: Deutsche Börse Photography Prize 2011', *AnOtherMag.com*, 8 April 2011
Hodgson, Francis, 'The Irony Age', *Financial Times*, 8 April 2011
'Deutsche Börse', *i-D*, No.312, Spring 2011
Pollack, Barbara, 'Talking with Bice Curiger VENI, VIDI, VICI, VENICE: An Inside Look at the Venice Biennale,' *artnet.com*, 1 April 2011
Liu, Congyun, 'Elad Lassry: Collapse and Reconstruction', *Photoworld*, No.352, April 2011, pp.108–111
Gegner, Andreas, 'Exploring: London', *Art Investor*, April 2011, p.30
Davies, Lucy, 'Elad Lassry: New frames of reference,' *The Telegraph*, 25 March 2011
'Shortlist announced for Deutsche Börse Photography Prize 2011', *FlashArtonline.com*, March 2011
'Curator Bice Curiger announces Venice artists', *ArtReview.com*, 12 March 2011
Davis, Ben, 'Venice Biennale Releases Artist List for 2011 'ILLUMInations' Exhibition', *artinfo.com*, 11 March 2011
'Omer Fast, Dani Gal, and Elad Lassry in 'ILLUMInations' at the 2011 Venice Biennale, curated by Bice Curiger', *ArtisContemporary.org*, 11 March 2011
Finkel, Jori, 'MOCA acquires board members and works by Arceneaux, Beshty, Lassry, Ruby and more', *Los Angeles Times*, 16 March 2011
Pym, William, 'Elad Lassry', *Art Asia Pacific*, No.72, March–April 2011
Schmerler, Sarah, 'Elad Lassry', *Art in America*, March 2011, pp.154–155
Olu, Amani, 'Elad Lassry', *Whitewall*, Winter 2011, pp.52–53
Masters, H.G., 'The Memorable Among the Many', *Art Asia Pacific*, Vol.6, *Almanac* 2011, p.228
Volpi, Bruna and Ashita Nagesh, 'Elad Lassry – The Status of Image', *Kilimanjaro – Thinking of Collective*, No.12, 2011
Matalon, Rebecca, 'Elad Lassry', *Kaleidoscope*, No.9, Winter 2010–2011, p.152
Bordignon, Elena, 'Art's Top Ten 2010', *vogue.it*, 31 December 2010
Herschthal, Eric, 'Art and Israel: Some Sunny News', *TheJewishWeek.com*, 8 December 2010
Bollen, Christopher, 'L.A. Artworld', *Interview*, December–January 2011, p.106
Schwendener, Martha, 'Focus Here! A Round-up of Current Photography Exhibits', *Village Voice*, 1 December 2010
Gopnik, Blake, 'Gopnik's Daily Pic: Elad Lassry at Luhring-Augustine',

WashingtonPost.com, 19 November 2010

Fowler, Brendan, 'Elad Lassry', *ANPQuarterly*, Vol.2, No.5, November 2010, pp.54–65

Baran, Jessica, 'St. Louis Art Capsules', *RiverfrontTimes.com*, 27 October 2010

Aletti, Vince, 'Cool Hunters', *The New Yorker*, 18 October 2010, p.12

Weaver, Cat, 'MoMA's New Photography 2010: Post-Appropriation', *Huffingtonpost.com*, 13 October 2010

Yablonsky, Linda, 'Art and Action', *New York Times: TMagazine.com*, 8 October 2010

Rosenberg, Karen, 'Ignoring Boundaries and Borrowing Freely', *New York Times*, 8 October 2010, p.28

Cattelan, Maurizio, 'Take a Break', *Flash Art*, October 2010, pp.88–91

Griffin, Jonathan, 'City Report: Los Angeles', *Frieze*, No.134, October 2010, pp.227–229

Pulimood, Steve, 'Art and Artifice', *Modern Painters*, October 2010, pp. 46–47

Hameiri, Yham, 'At Home Abroad', *Haaretz.com*, 8 September 2010

Gartenfeld, Alex, 'The 'Mad Men' Photographer', *The New York Observer*, 7 September 2010

Kastner, Jeffrey, 'Previews: Elad Lassry', *Artforum*, September 2010, p.166

Vogel, Carol, 'New Photography 2010 Coming to MOMA', *New York Times*, 29 July 2010, p.24

Javitch, Daphne, 'Elad Lassry', *L'Officiel Hommes*, No.20, June–August 2010, pp.100–103

Obrist, Hans Ulrich, 'Kunst im 21. Jahrhundert: Kuratiert von Hans Ulrich Obrist', *Du Magazin*, No.807, June 2010, pp.66–67

Moshayedi, Aram, 'Work in Progress: Elad Lassry', *Bidoun*, Summer 2010, pp.34–35

'Hijacked in a Winter Moment: Cay Sophie Rabinowitz with Erin Tao in conversation with Elad Lassry', *Fantom*, No.3, Spring 2010, pp.84–95

Baier, Simon, 'Elad Lassry', *Spike*, No.23, Spring 2010, p.133

Sholis, Brian, 'Dance With Camera', *Aperture*, Spring 2010, p.14

Trembley, Nicolas, 'Au-dela du reel', *Numero*, No.110, February 2010, p.60

Lay Flat 02: Meta, February 2010

Velasco, David, 'White Columns Annual', *Artforum*, February 2010, pp.204–205

Rabottini, Alessandro, 'Looking Forward', *Frieze*, No.128, January–February 2010, p.93

Léith, Caoimhin Mac Giolla, 'Looking Back: Emerging Artists', *Frieze*, No.128, January–February 2010, p.90

Cotter, Holland, 'The Perpetual Dialogue', *New York Times*, 8 January 2010, p.32

Israel, Alex, 'Myths of Decline', *Artforum*, January 2010, pp.67–70

Blind Spot, No.41, 2009

Walleston, Aimee, 'Elad Lassry's New Show', *The Last Magazine*, Issue 3, 2009, p.10

Kraus, Lisa, 'Dancing through lens', *The Philadelphia Inquirer*, 22 December 2009

Pagel, David, 'The Newest', *Los Angeles Times.com*, 18 December 2009

Bollen, Christopher, 'Rated Art', *Interview*, December 2009, p.149

Holte, Michael Ned, 'Best of 2009', *Artforum*, December 2009, p.192

Lassry, Elad, 'The Artists' Artists', *Artforum*, December 2009, p.88

Davies, Lucy, 'Pete and Repeat at 176 Gallery,' *The Telegraph*, 29

October 2009

Miles, Christopher, 'Elad Lassry', *LA Weekly*, 21 October 2009

Knight, Christopher, 'Photographs that ask questions', *Los Angeles Times*, 16 October 2009

Trezzi, Nicola, 'Re: Diaspora', *Flash Art*, October 2009, pp.66–69

Lehrer-Graiwer, Sarah, 'Openings: Elad Lassry', *Artforum*, October 2009, pp.218–221

Gartenfeld, Alex, 'Elad Lassry's Material Context', *ArtInAmerica.com*, 23 September 2009

Lehrer-Graiwer, Sarah, 'Elad Lassry', *artslant.com*, 21 September 2009

Young, Paul, 'Direct to Video!' *Angeleno*, September 2009, pp.75–76

Metropolis M, August–September 2009, pp.41–42, 85

'Best Art Show', *V Magazine*, No.61, Fall 2009, p.126

Kerr, Merrily, 'The Generational: Younger Than Jesus', *Flash Art*, July–September 2009, pp.27–28

Myers, Holly, 'Superficiality and Superexcrescence at Ben Maltz Gallery', *Los Angeles Times*, 8 July 2009

Gartenfeld, Alex, 'The Liste List', *ArtinAmerica.com*, 15 June 2009

Trembley, Nicholas, 'Time is money', *artforum.com*, 15 June 2009

Crow, Kelly, 'Window Shoppers', *Wall Street Journal*, 12 June 2009

Ebgi, Anat, 'Elad Lassry', *Artisrael.org*, June 2009

Cotter, Holland, 'Framing the Message of a Generation', *New York Times: Arts & Leisure*, 31 May 2009, pp.1, 25

Ascari, Alessio, 'Elad Lassry and Adrien Missika', *Kaleidoscope*, Summer 2009, pp.92–97

Castets, Simon, 'Splitting Image', *Vman.com*, 12 April 2009

'After Materiality and Style', *Art in America*, April 2009, pp.130–139, 162

'A Concerted Overview', *Kaleidoscope*, March–April 2009, pp.46, 54

Meade, Fionn, 'Elad Lassry: Three Films', *Bidoun*, Spring 2009, pp.167–168

Lehrer-Graiwer, Sarah, 'Studio Visit', *FlashArtonline.com*, 18 November 2008

Bollen, Christopher, 'Elad Lassry', *Interview*, November 2008, p.42

D'Aurizio, Michele, 'The Better Craftsman', *Mousse*, No.12, January 2008, pp.26–29

Holte, Michael Ned, 'Elad Lassry', *Artforum*, January 2008, pp.290–291

'Graduate Directory: Elad Lassry', *Wallpaper*, January 2008, p.94

Grosz, David, 'Weekend Picks: Elad Lassry in LA', *artinfo.com*, 16 November 2007

Schad, Ed, 'A Look at Lassry', *artslant.com*, November 2007

Donaldson, Sarah, 'Zoo is the fair with flair', *guardian.co.uk, Art and design blog*, 15 October 2007

Sholis, Brian, 'Deep Frieze', *artforum.com*, 14 October 2007

Buck, Louisa and Melanie Gerlis, 'Zoo's move out of the zoo is a success', *The Art Newspaper*, 12 October 2007, p.4

Gerlis, Melanie, 'And the champagne goes to...' *The Art Newspaper*, 12 October 2007, p.4

Muchnic, Suzanne, 'Giving local artists a good first shot', *Los Angeles Times*, 7 July 2006, p.27

Lambert, Alix, 'Top Ten', *Artforum*, November 2004, p.92

Published by White Cube on the occasion of:

Elad Lassry
White Cube Hoxton Square
23 September – 12 November 2011

Edited and coordinated by Honey Luard
Editorial assistance by Dorothy Feaver
Designed by Murray & Sorrell FUEL
Photography by Fredrik Nilsen
Produced by Hurtwood Press, Surrey

Artworks © Elad Lassry
Text © Douglas Crimp
Catalogue © White Cube

Douglas Crimp is Fanny Knapp Allen Professor of Art History at the University of
Rochester and the author of *On the Museum's Ruins* (1993) and *Melancholia
and Moralism: Essays on AIDS and Queer Politics* (2002). He was curator of the
'Pictures' exhibition at Artists Space, New York (1977) and an editor of *October*
(1977–90).

ISBN: 978-1-906072-47-6

White Cube
48 Hoxton Square
London N1 6PB

T: +44 (0)20 7930 5373
www.whitecube.com